This Notebook belongs to:

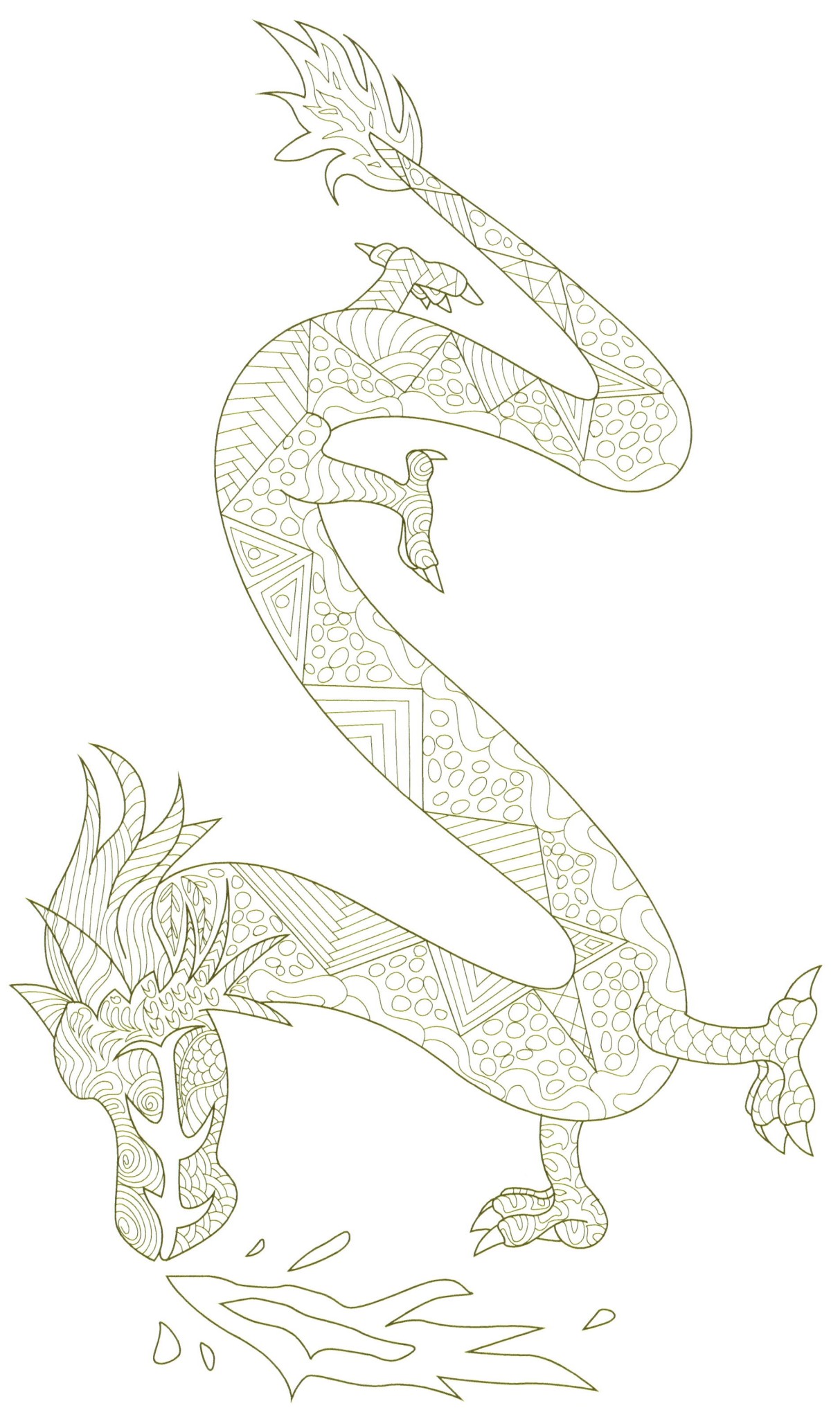

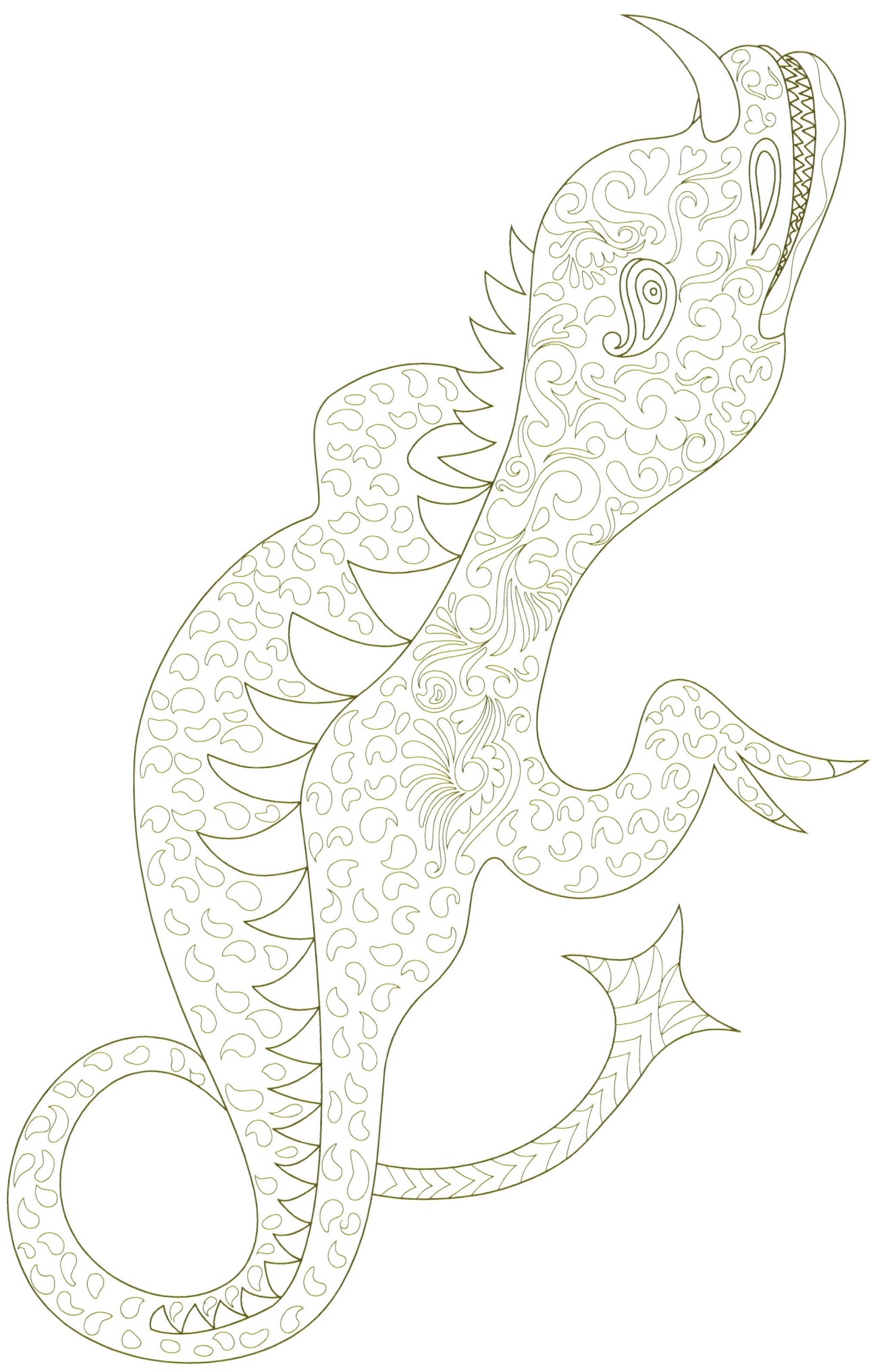

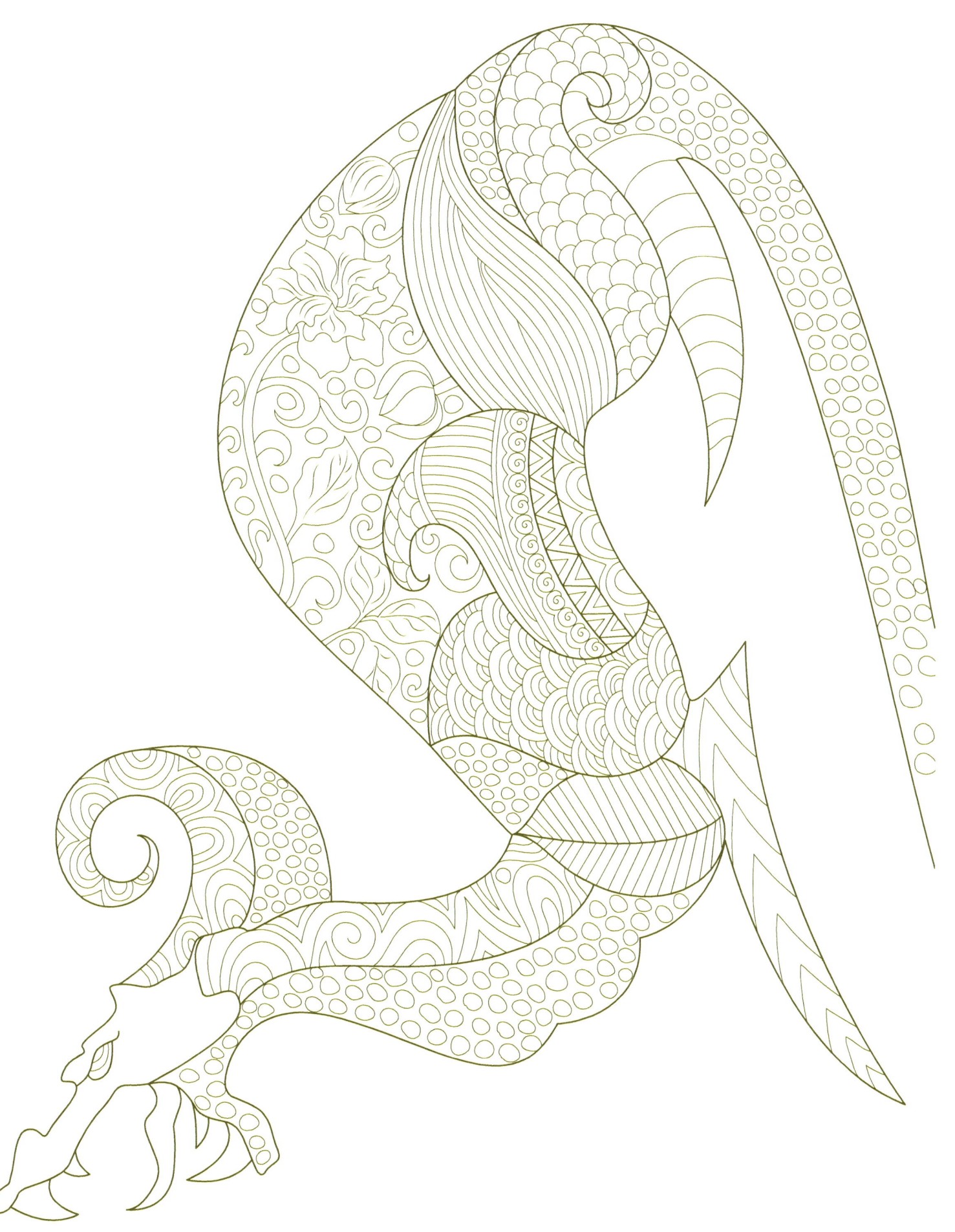

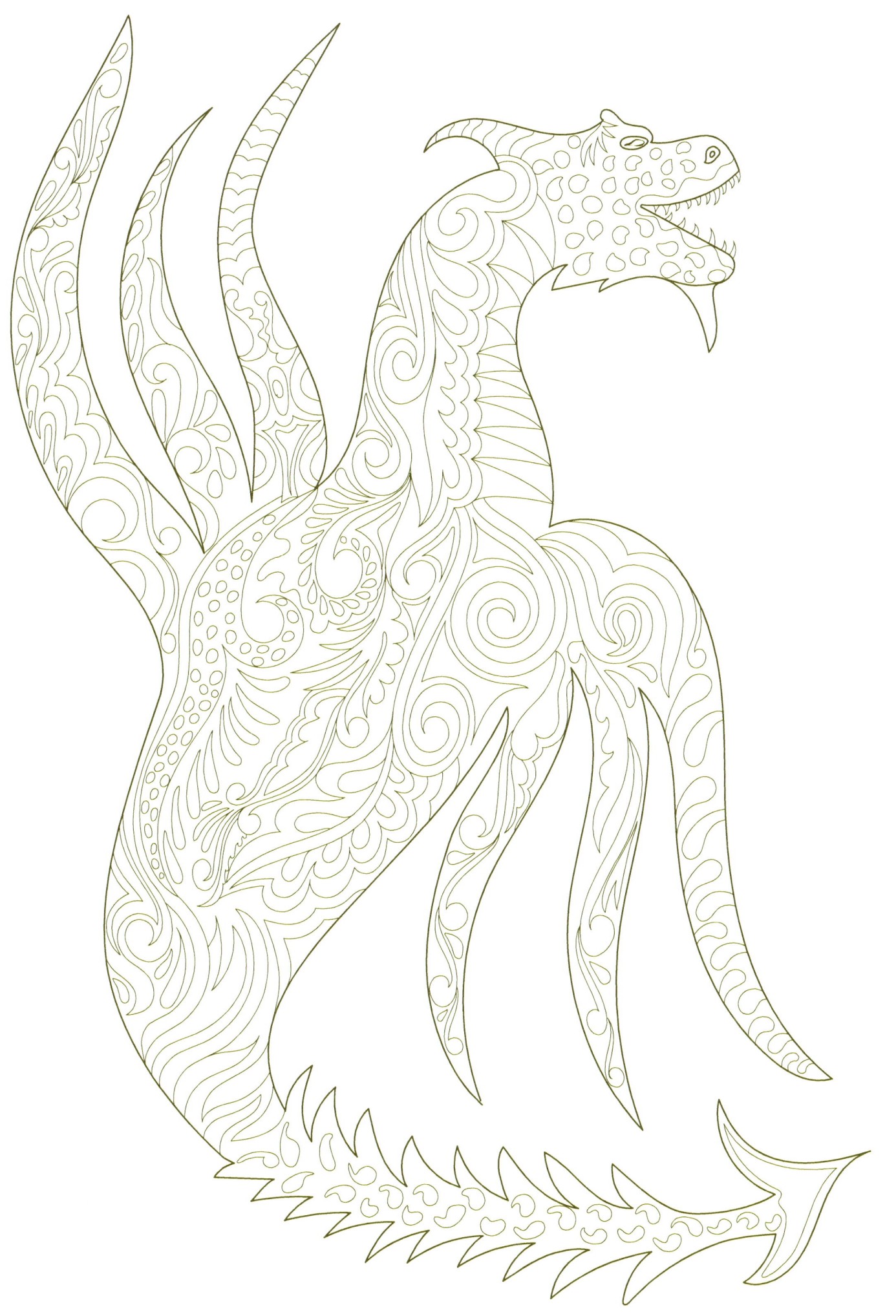

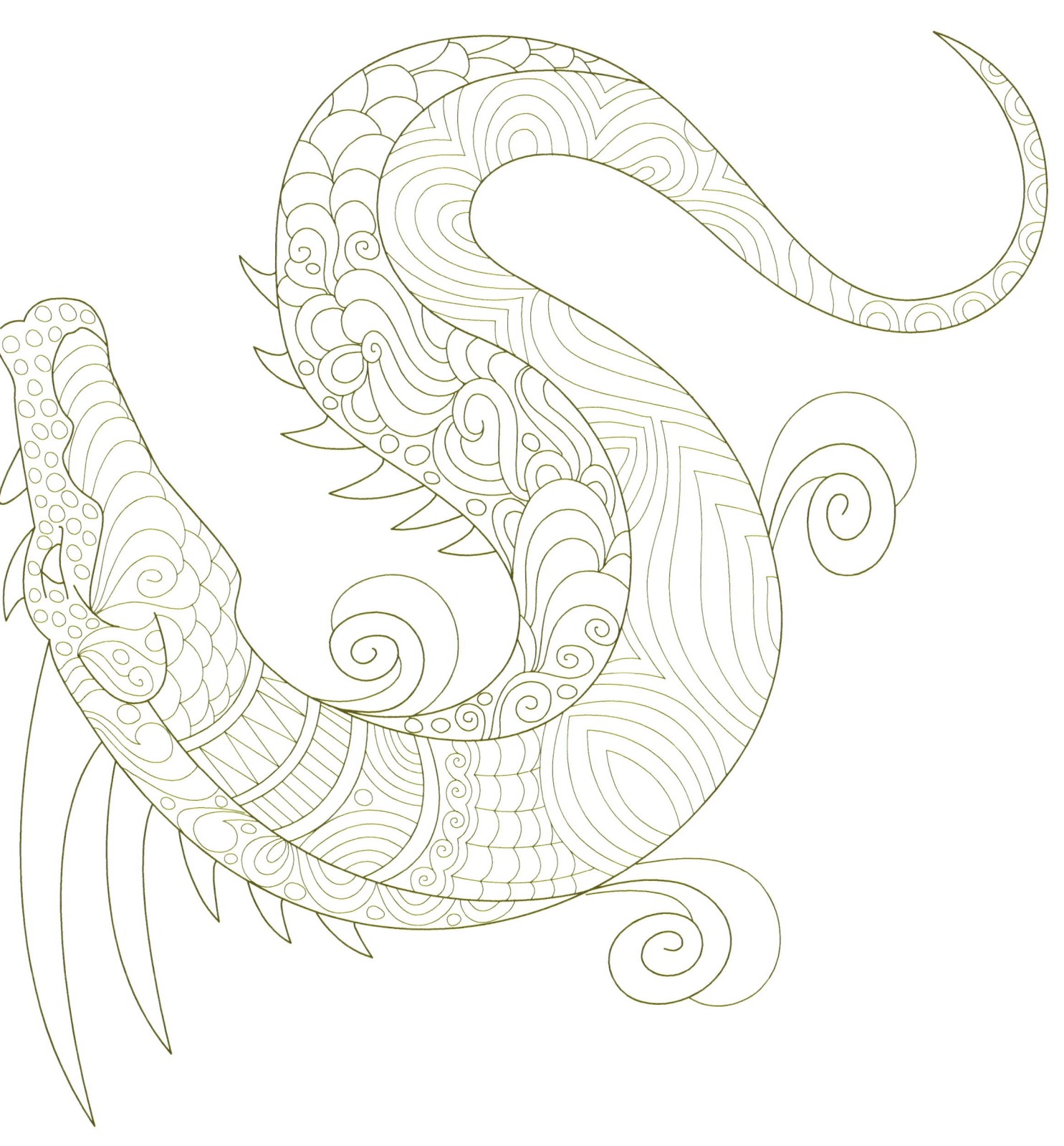

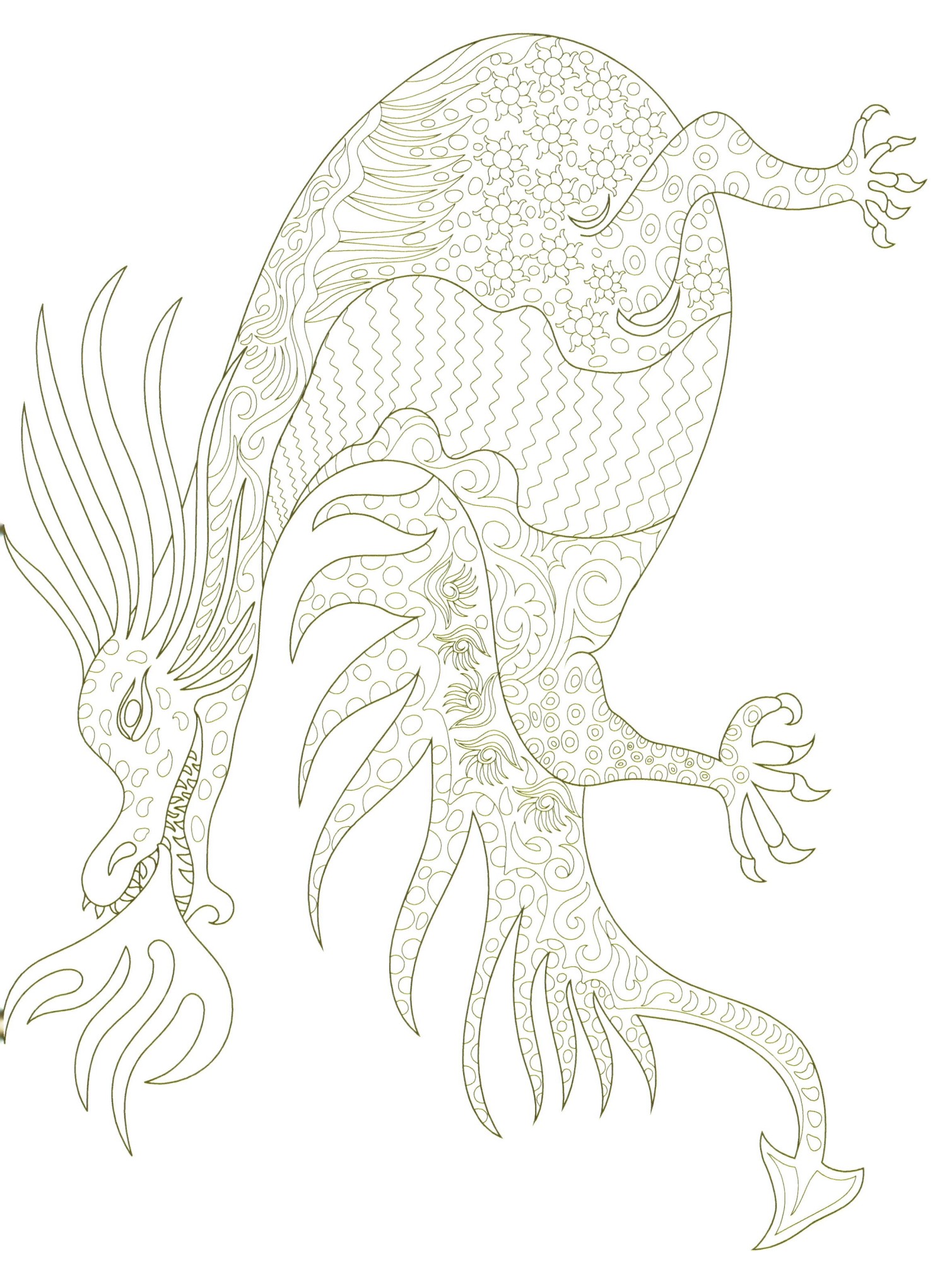

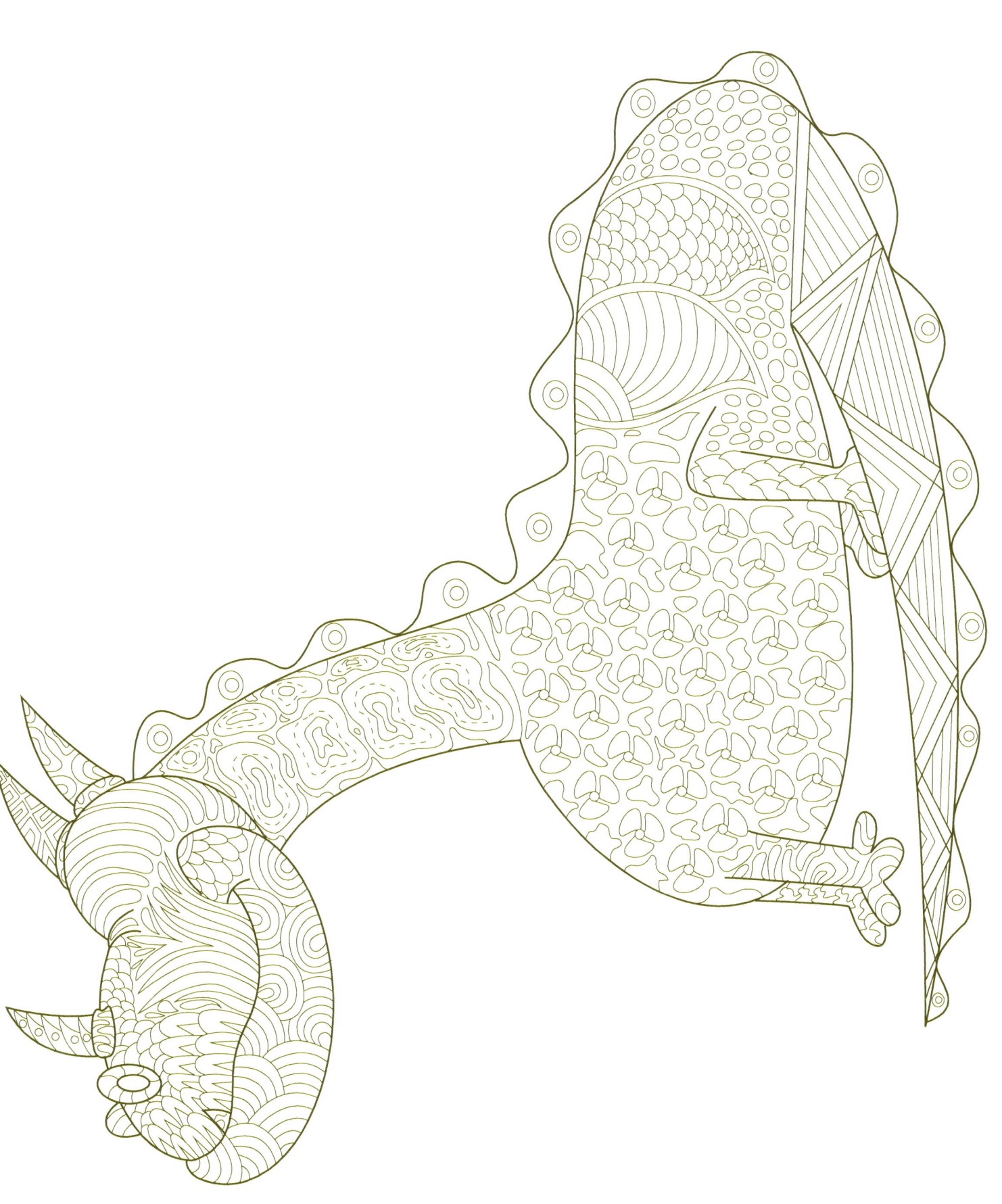

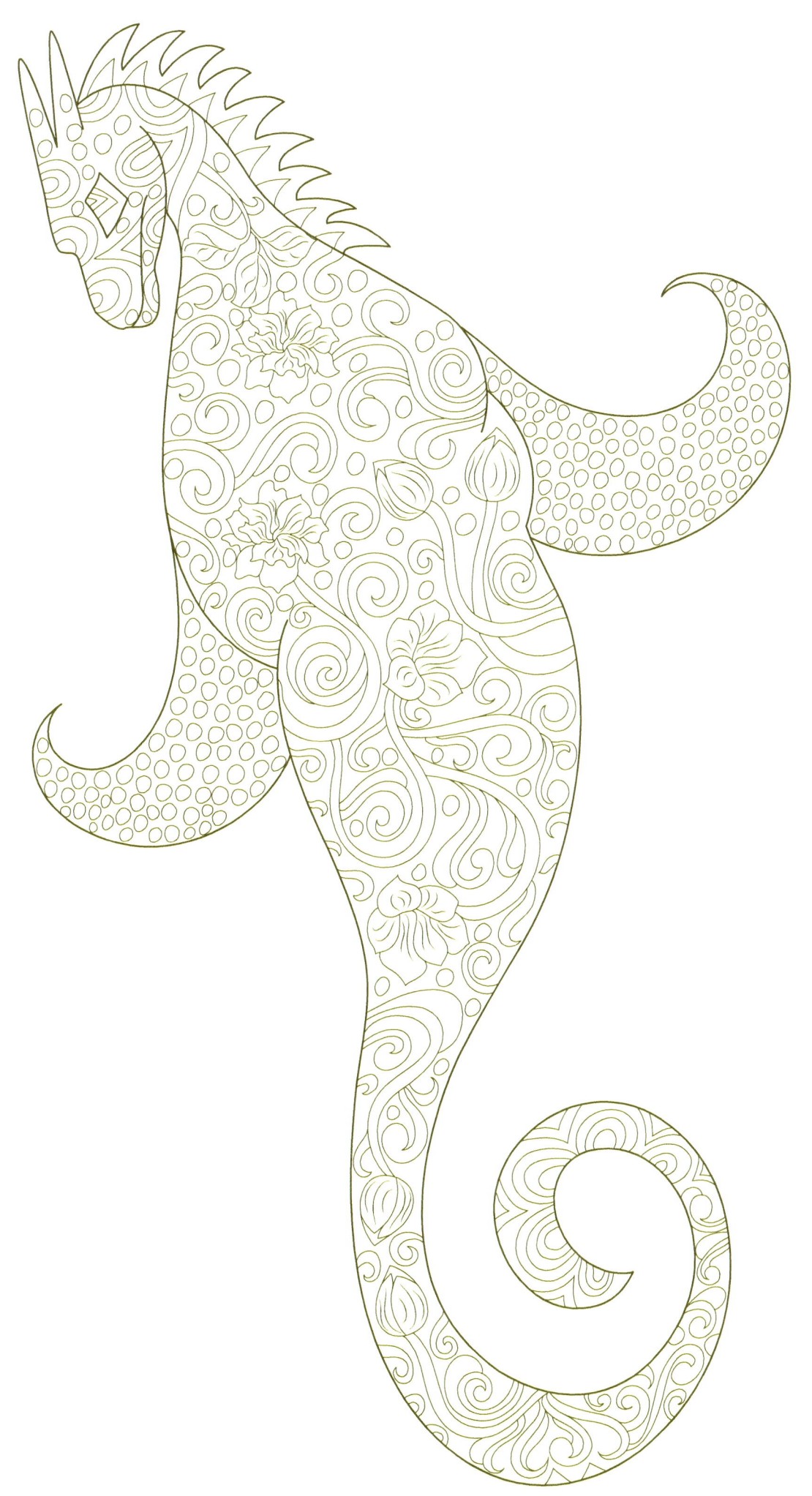

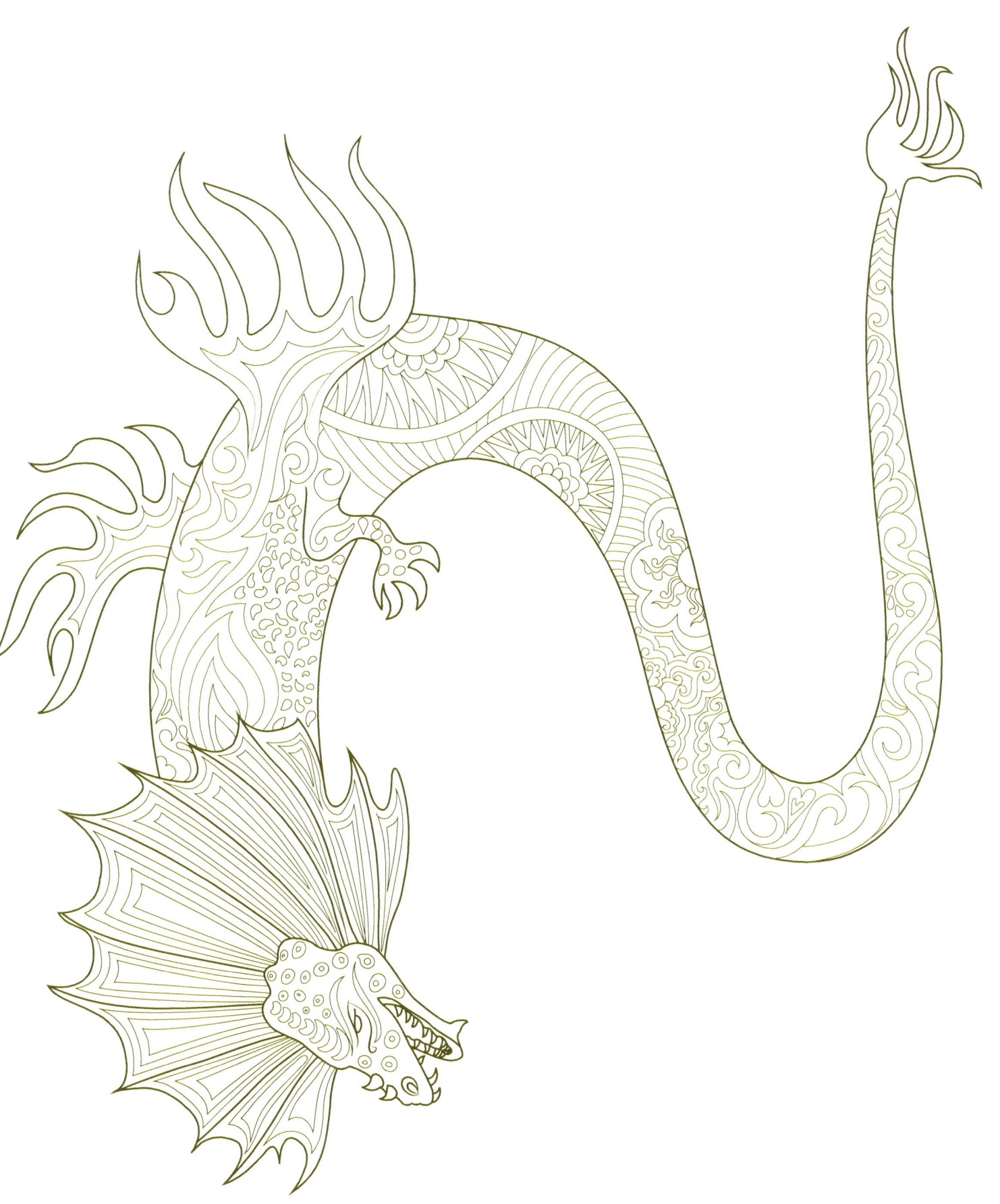

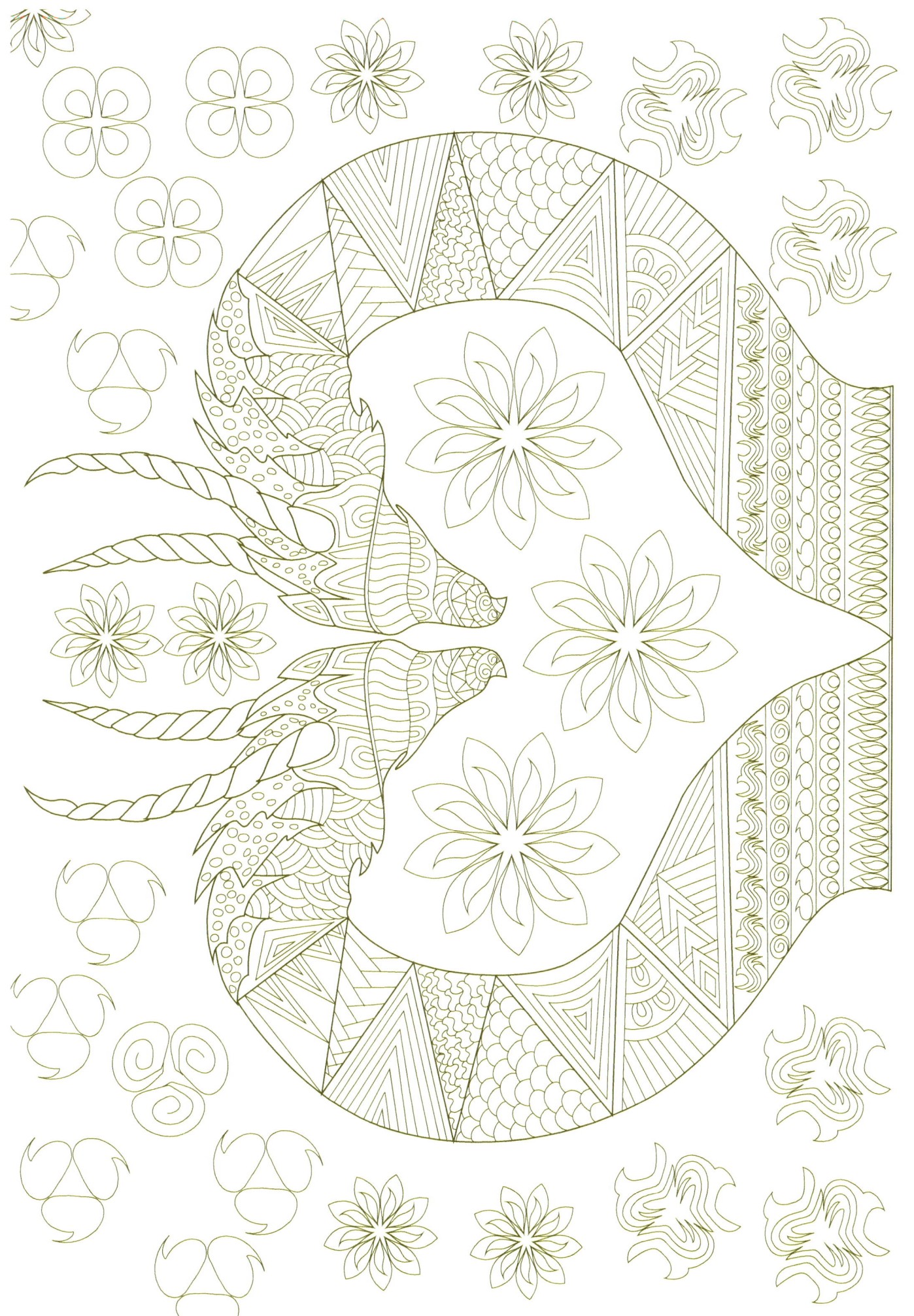

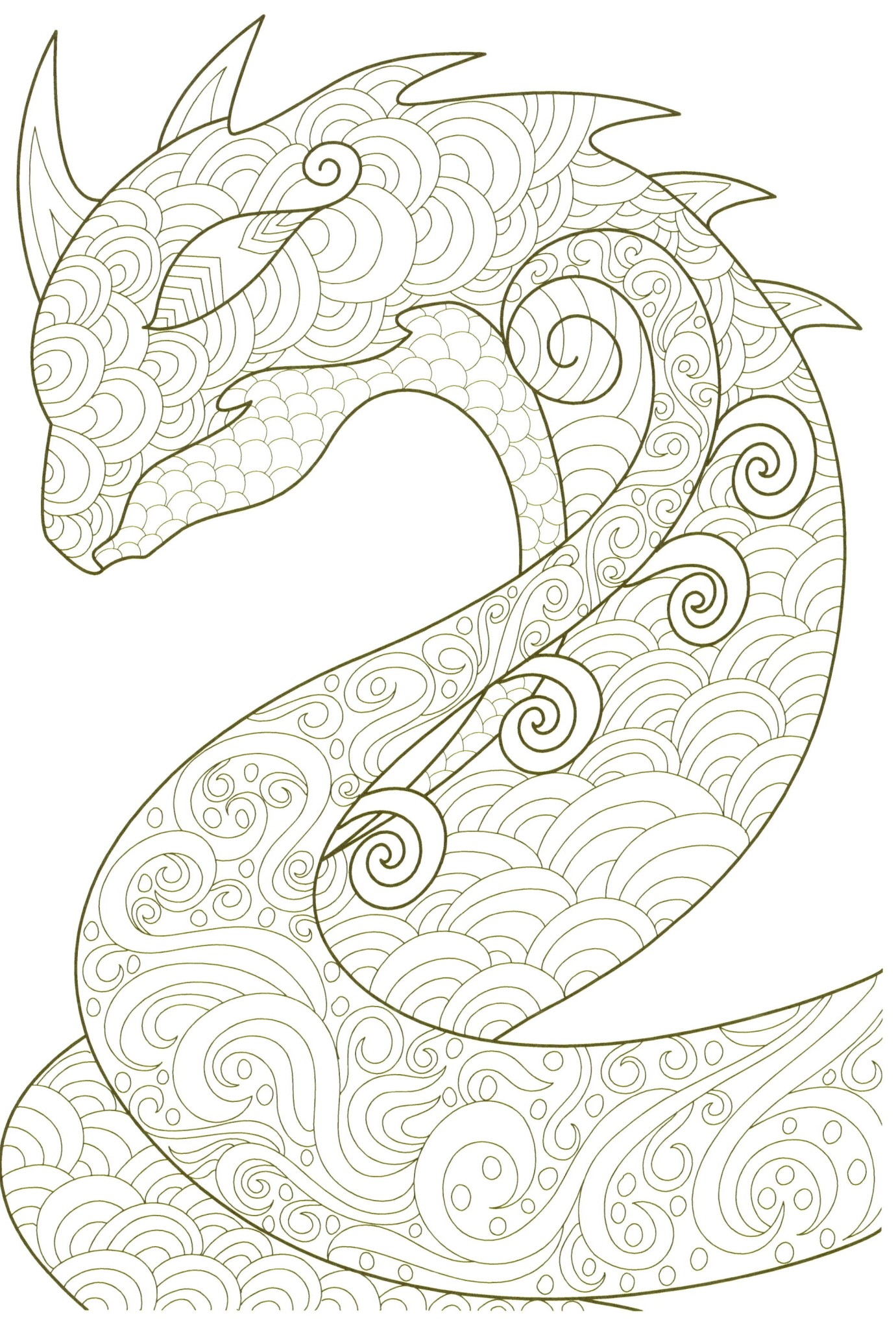

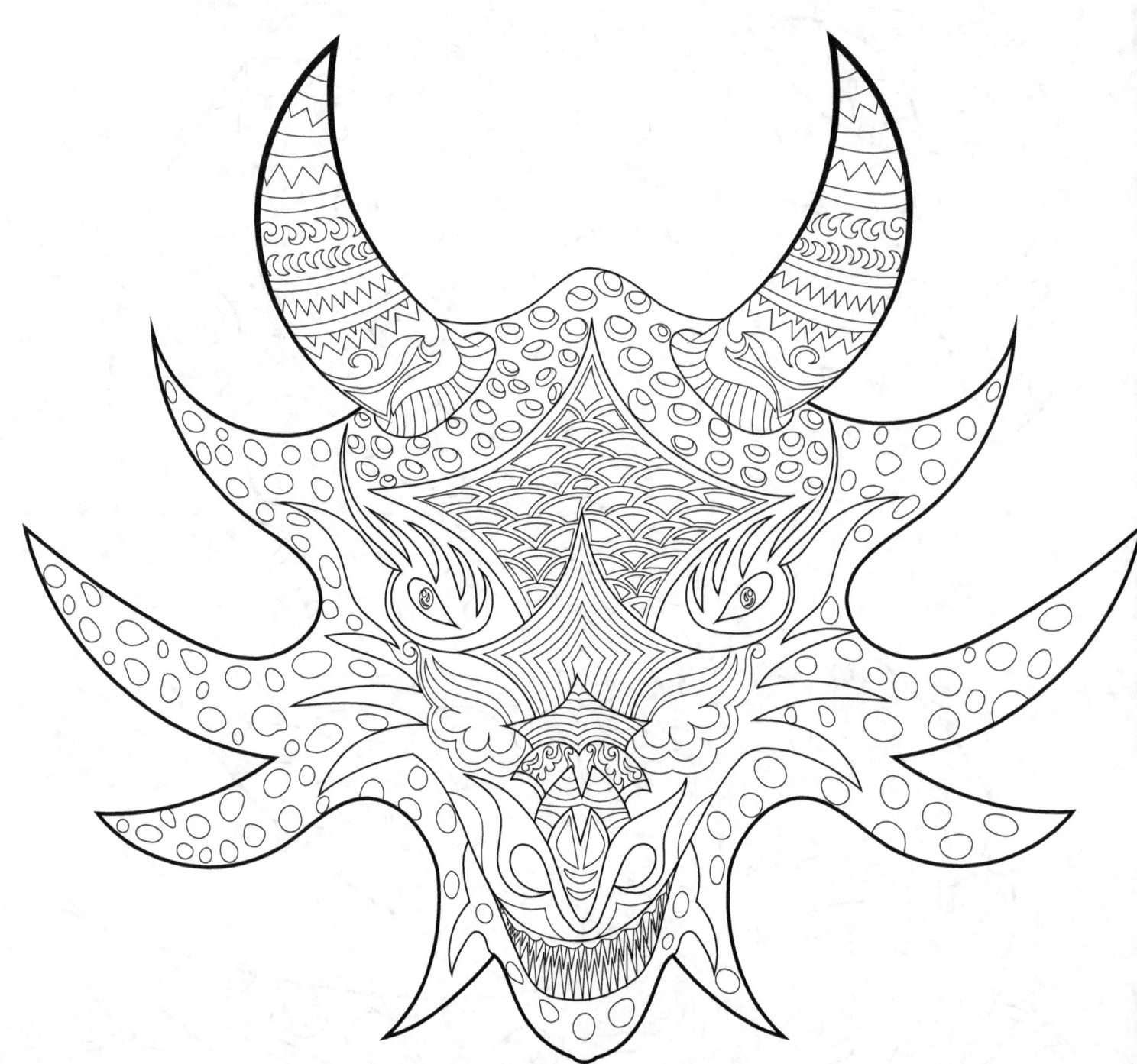

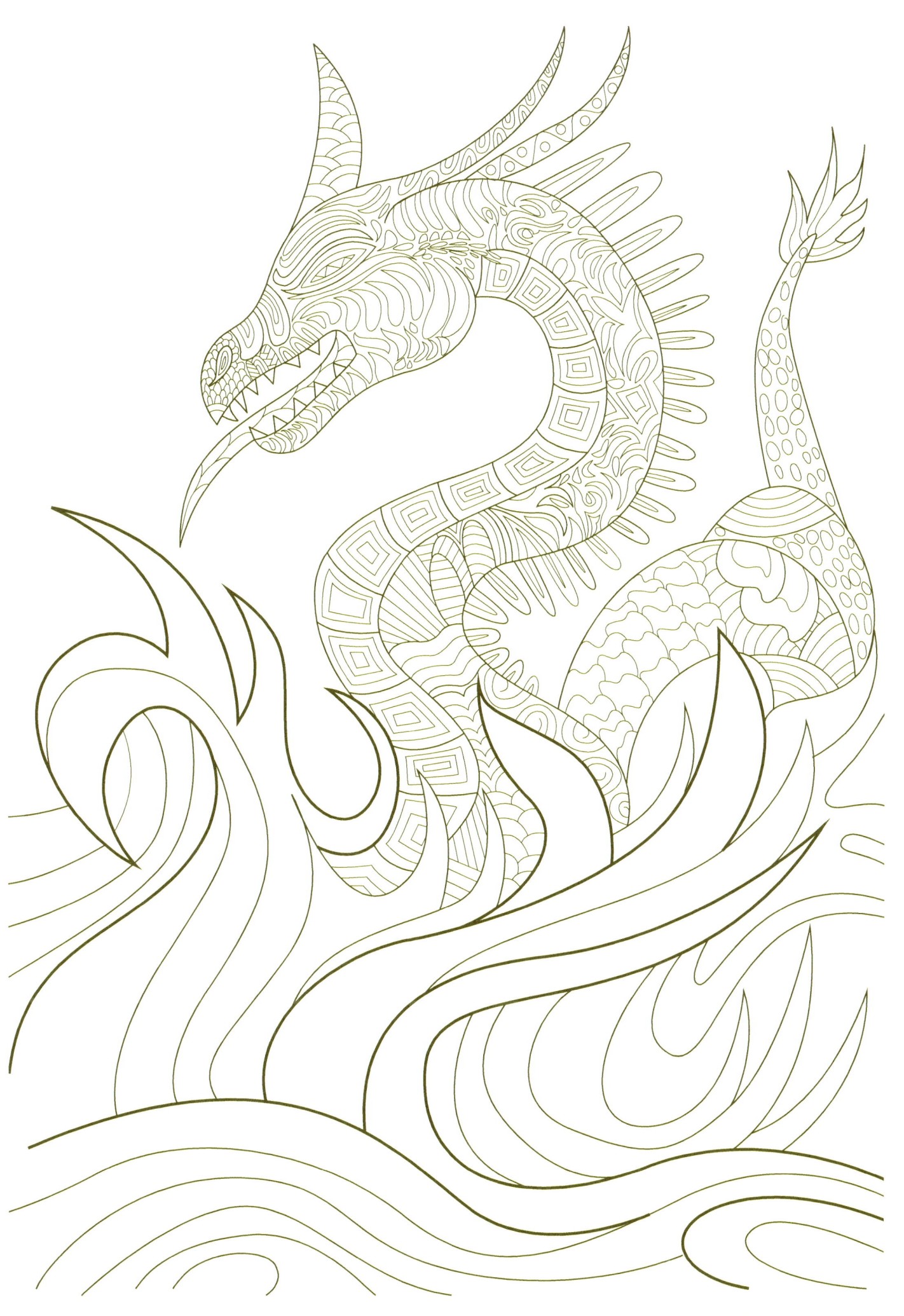

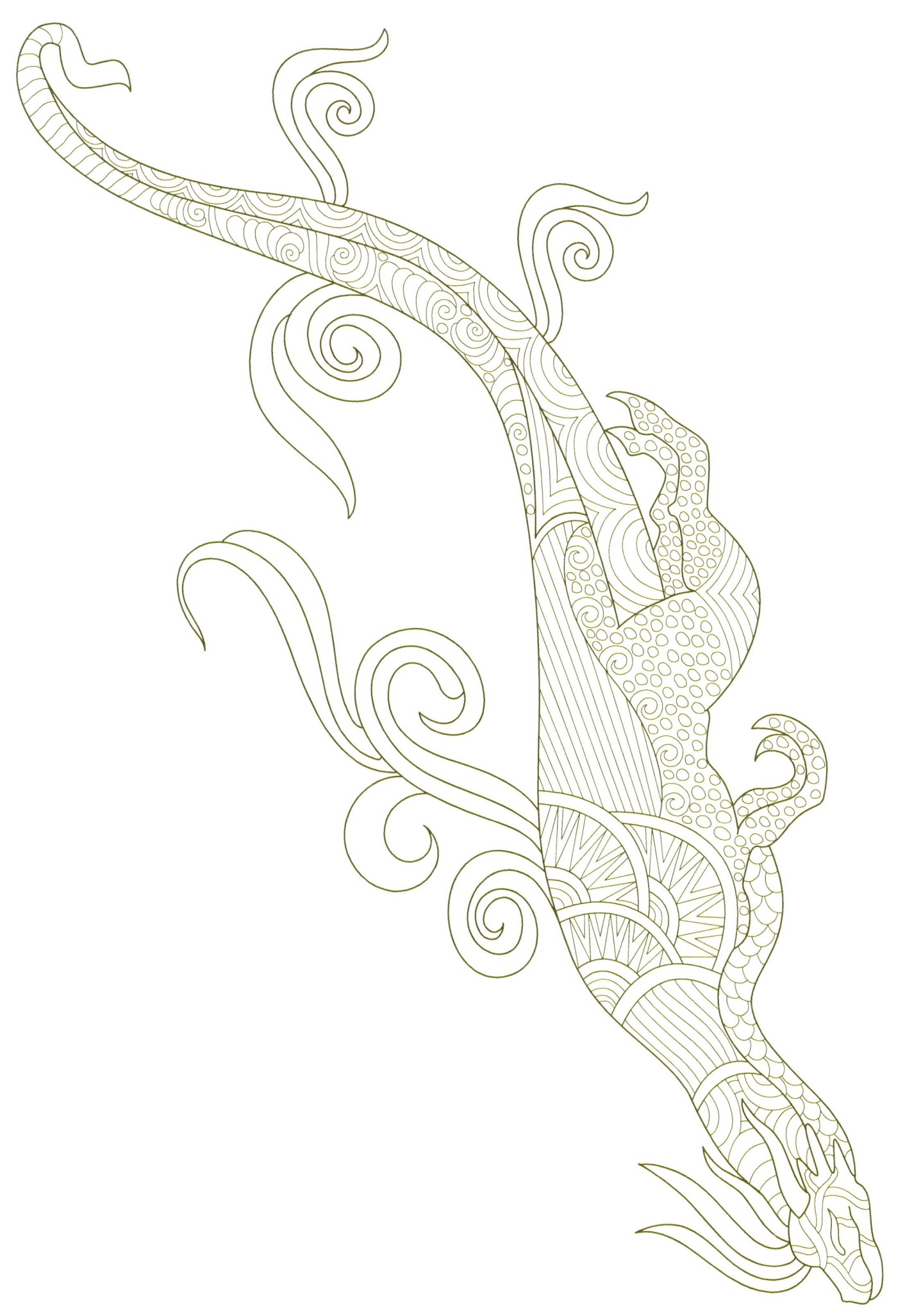

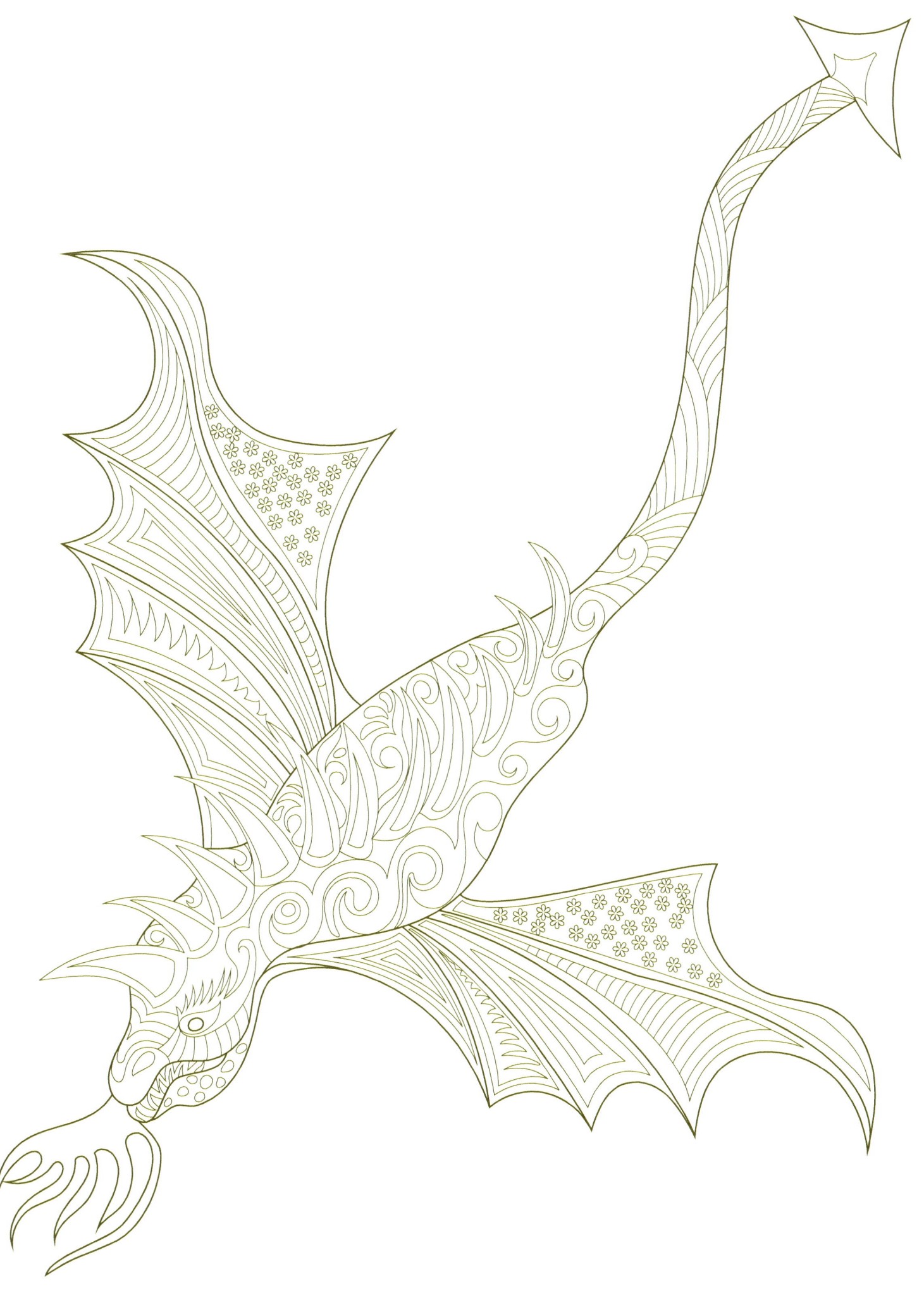

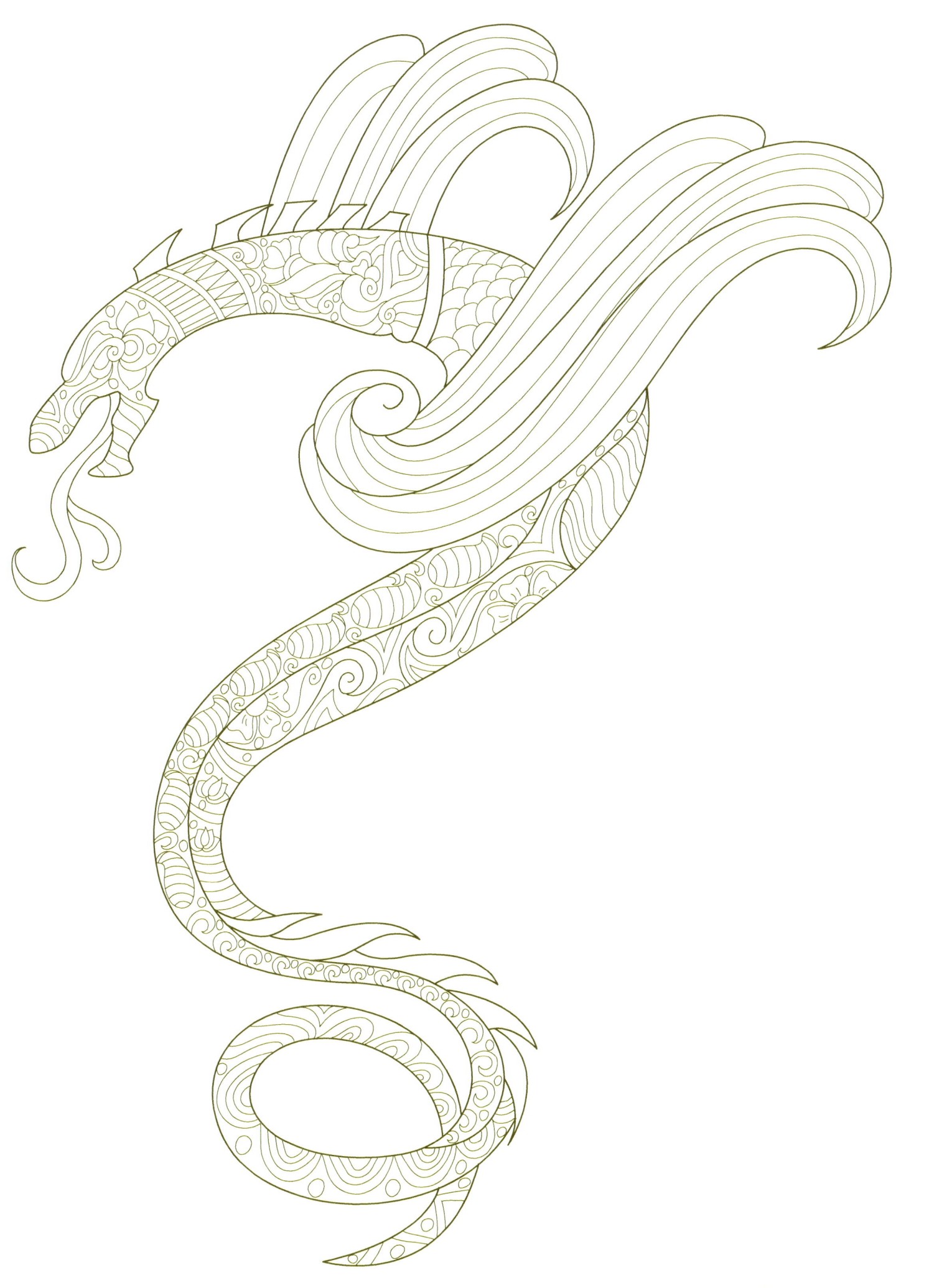

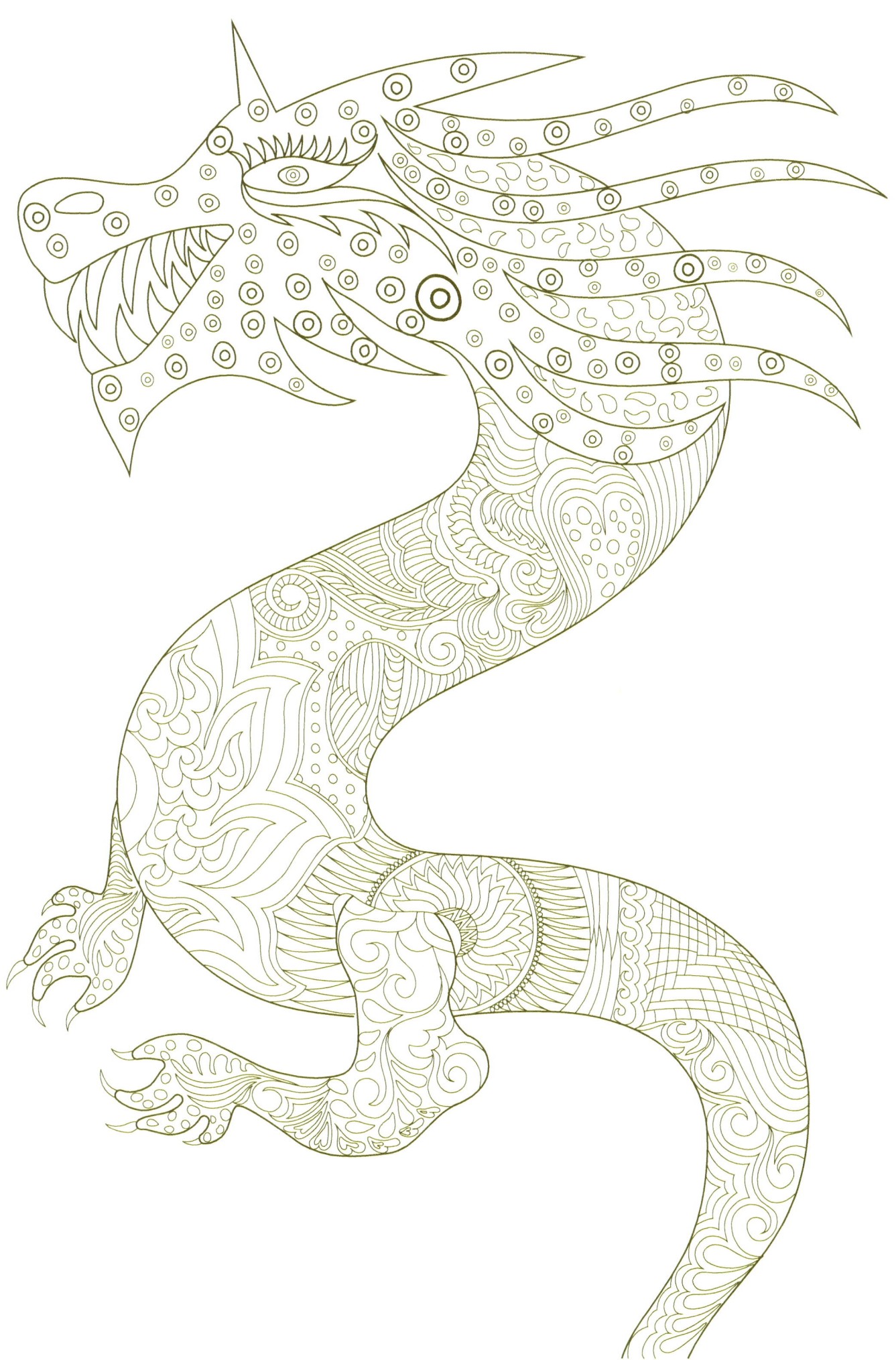

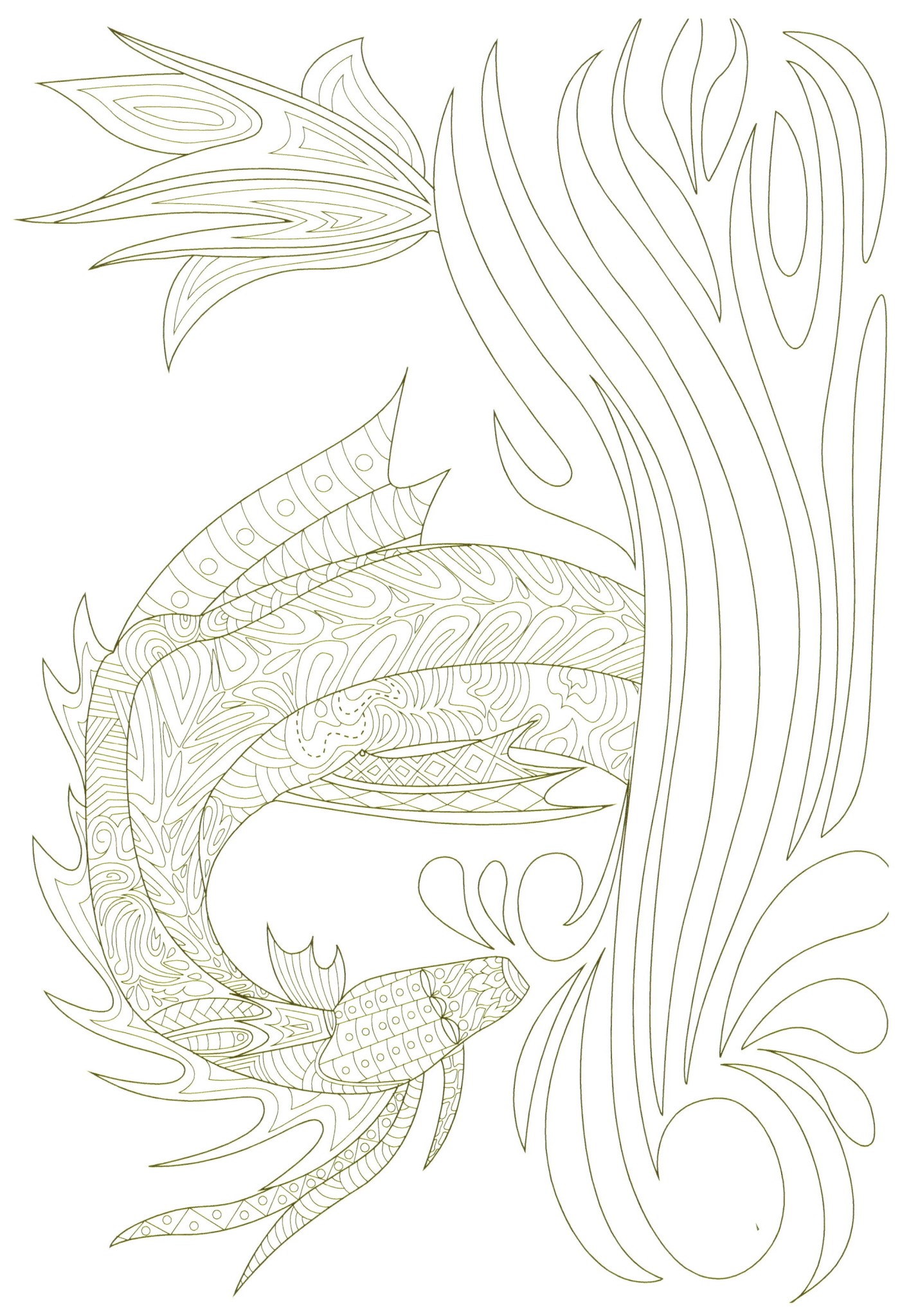

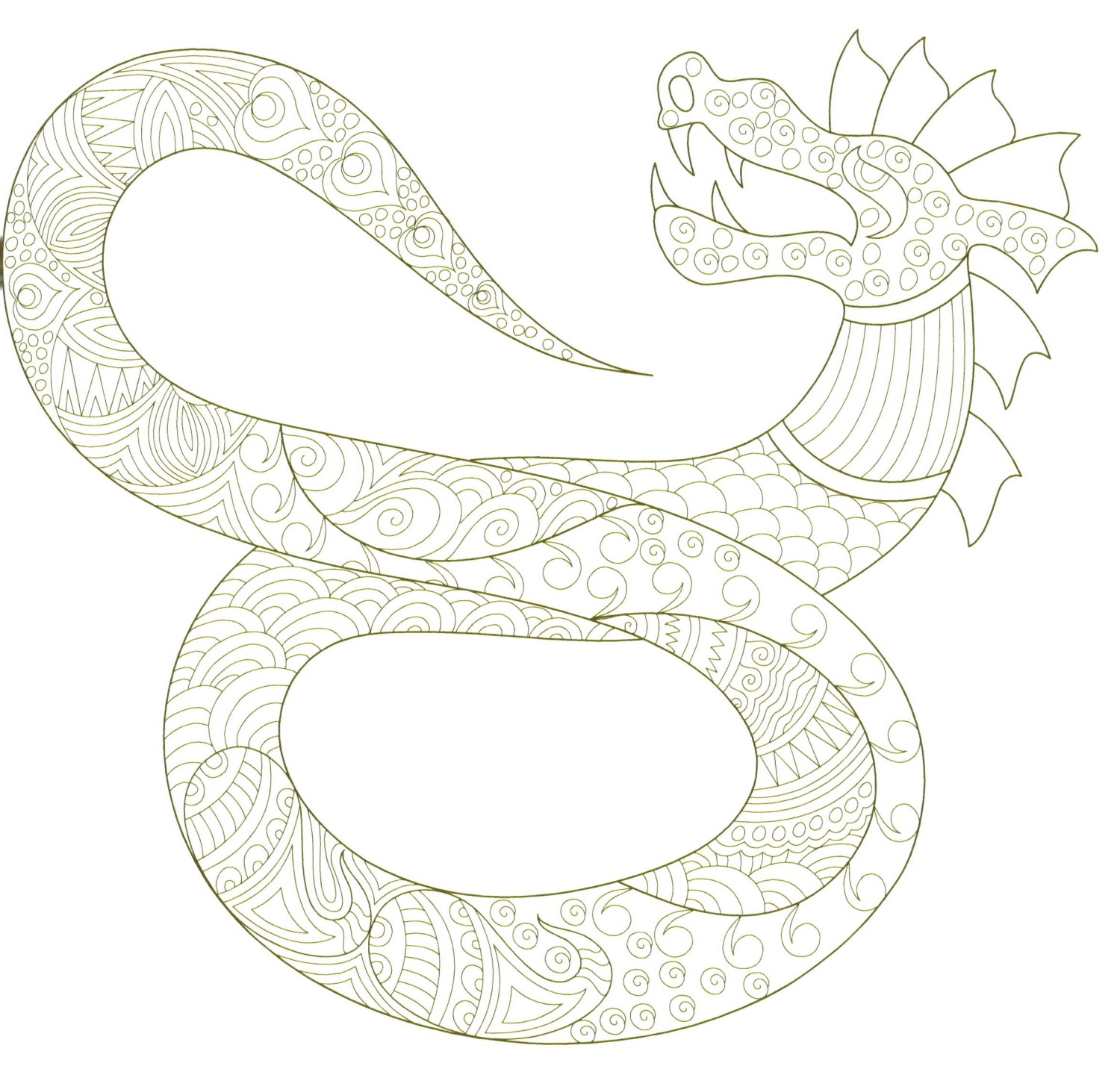

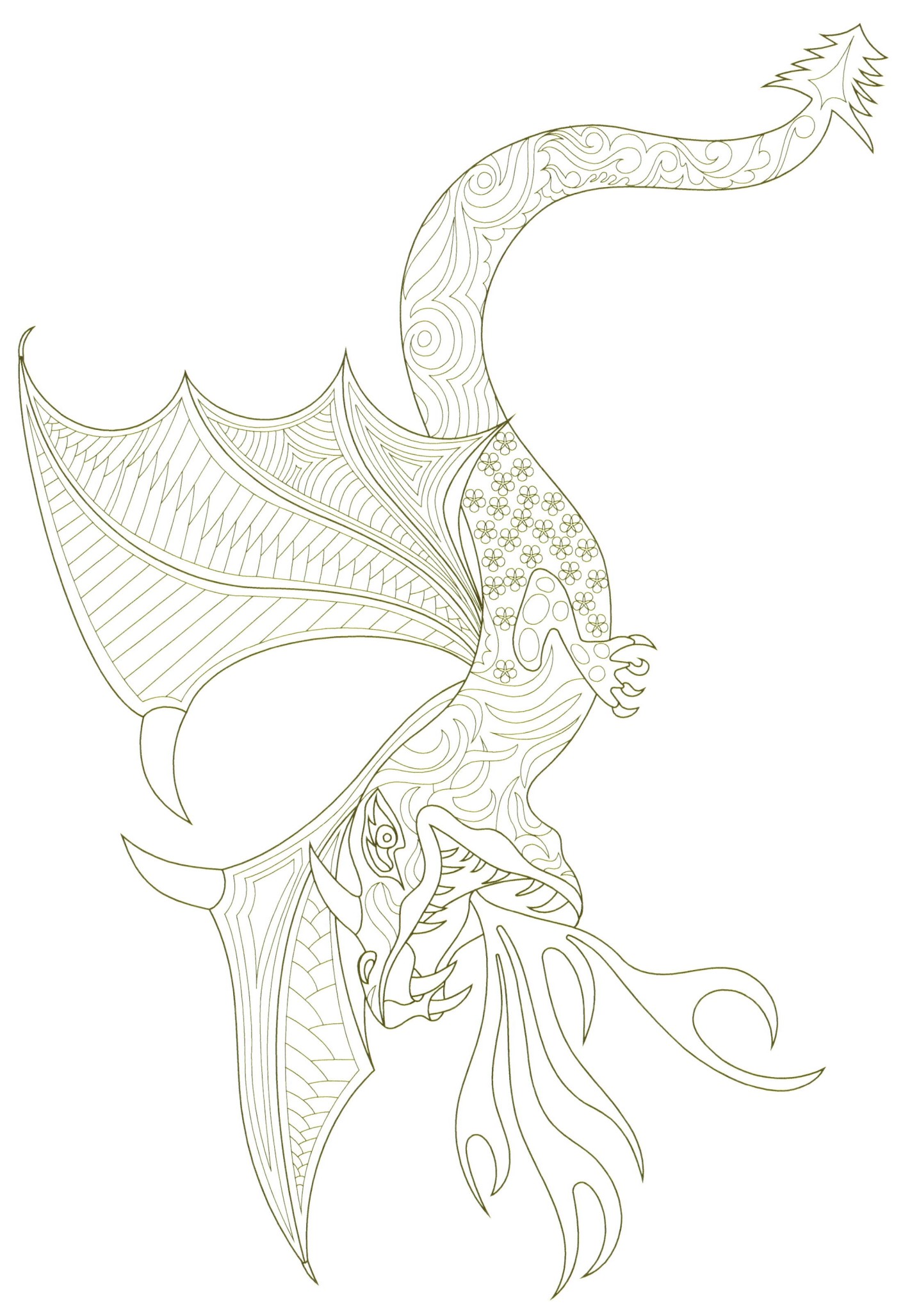

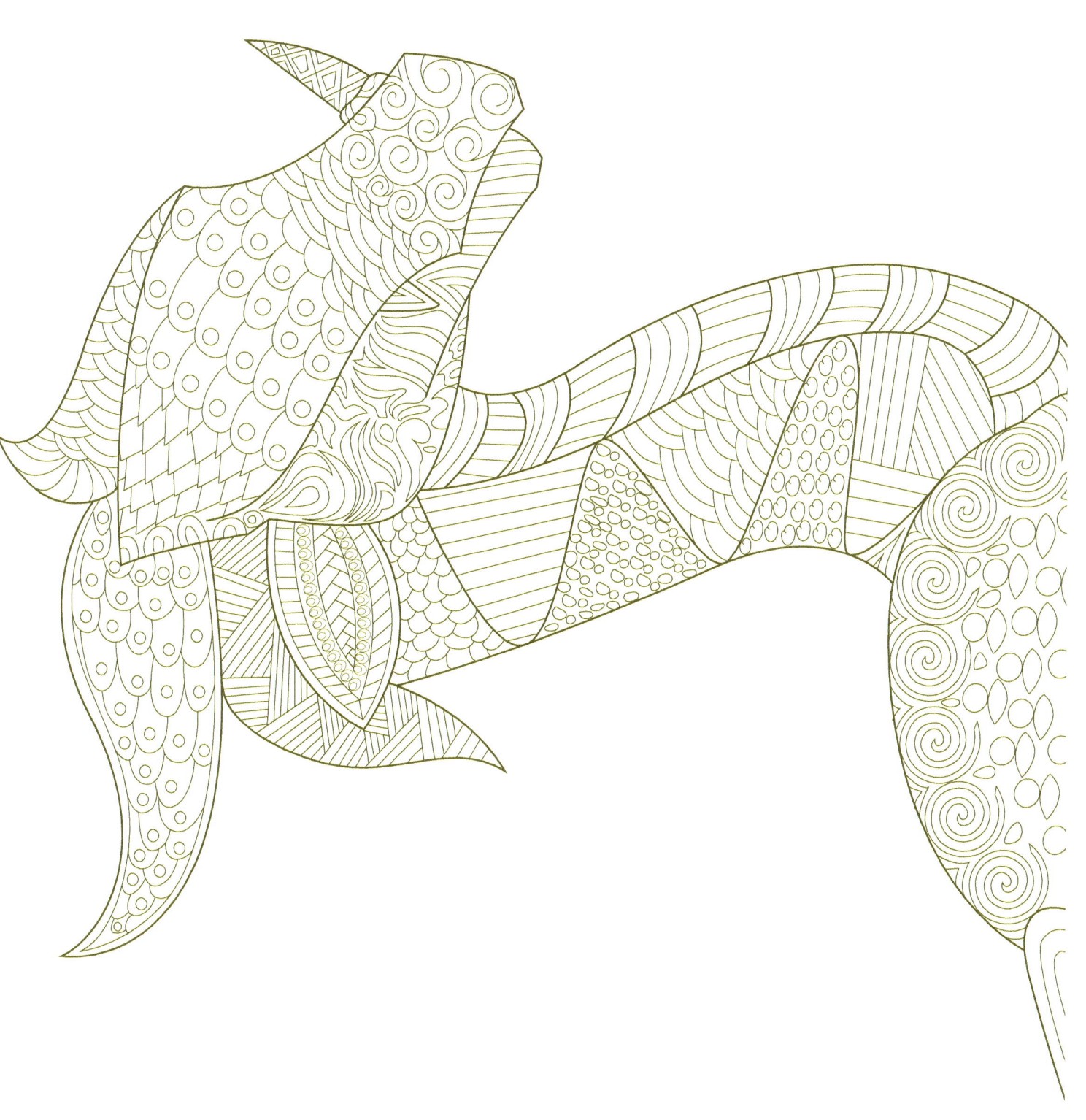

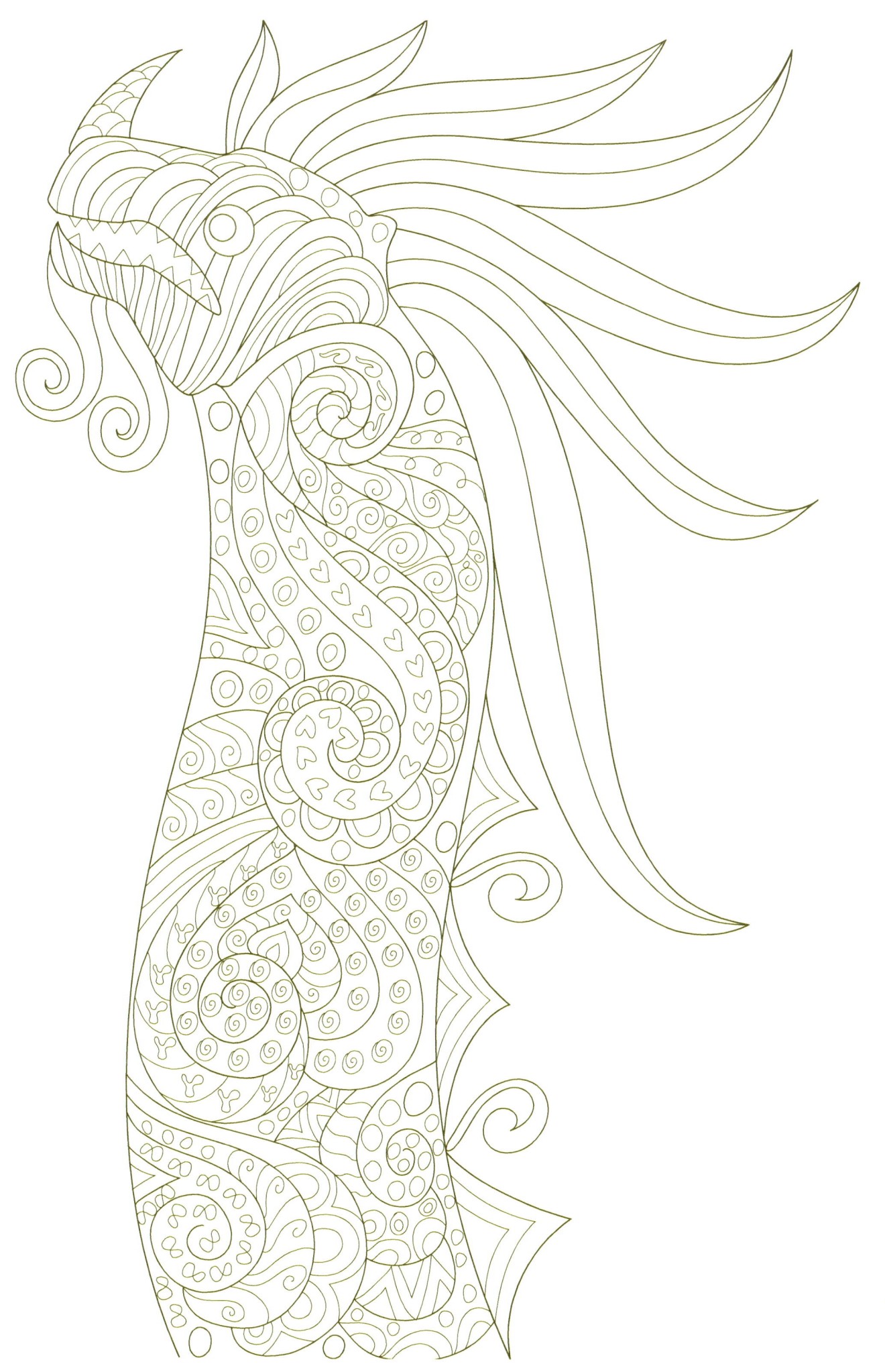

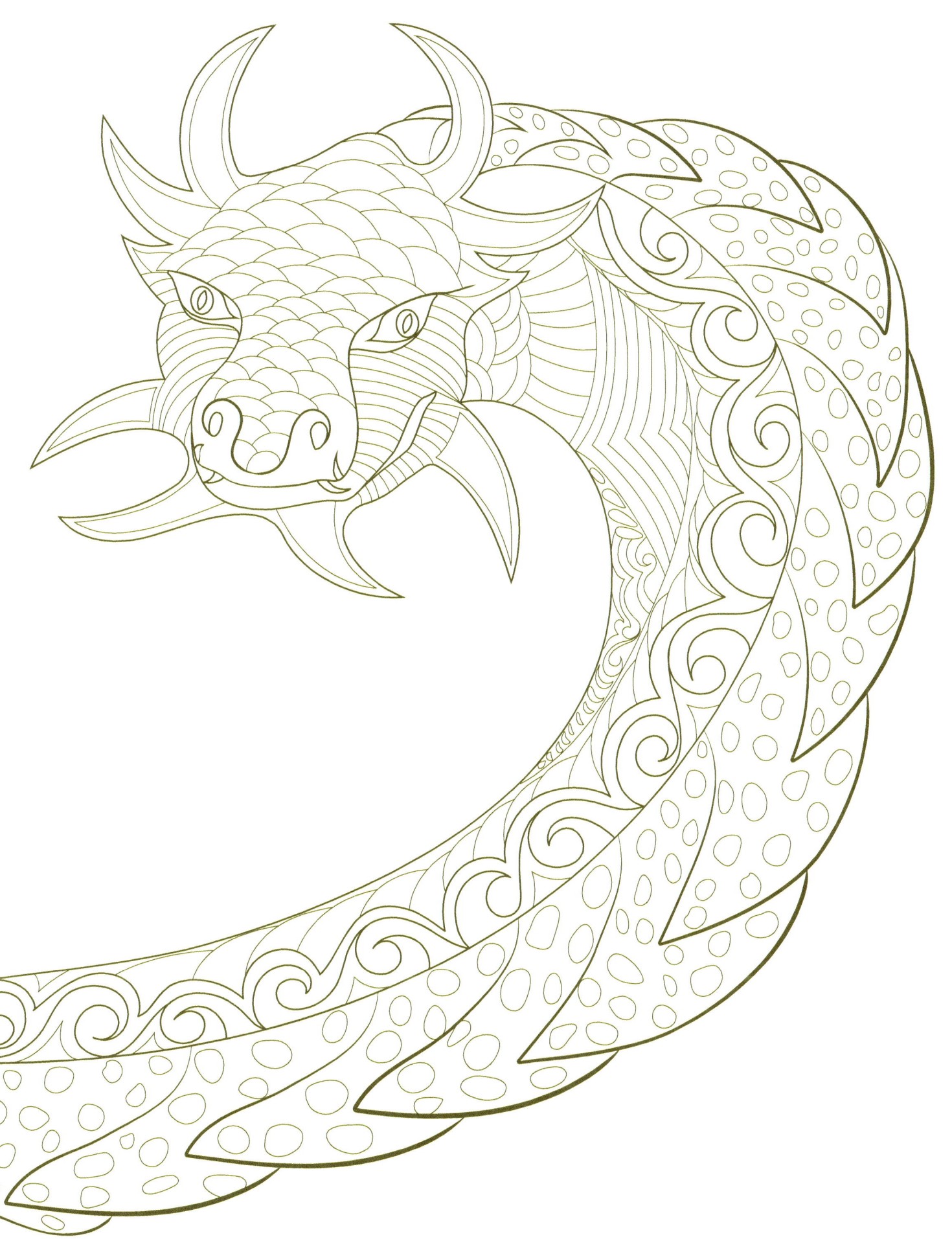

www.ingramcontent.com/pod-product-compliance
Lightning Source LLC
Chambersburg PA
CBHW081501220526
45466CB00008B/2740

solution

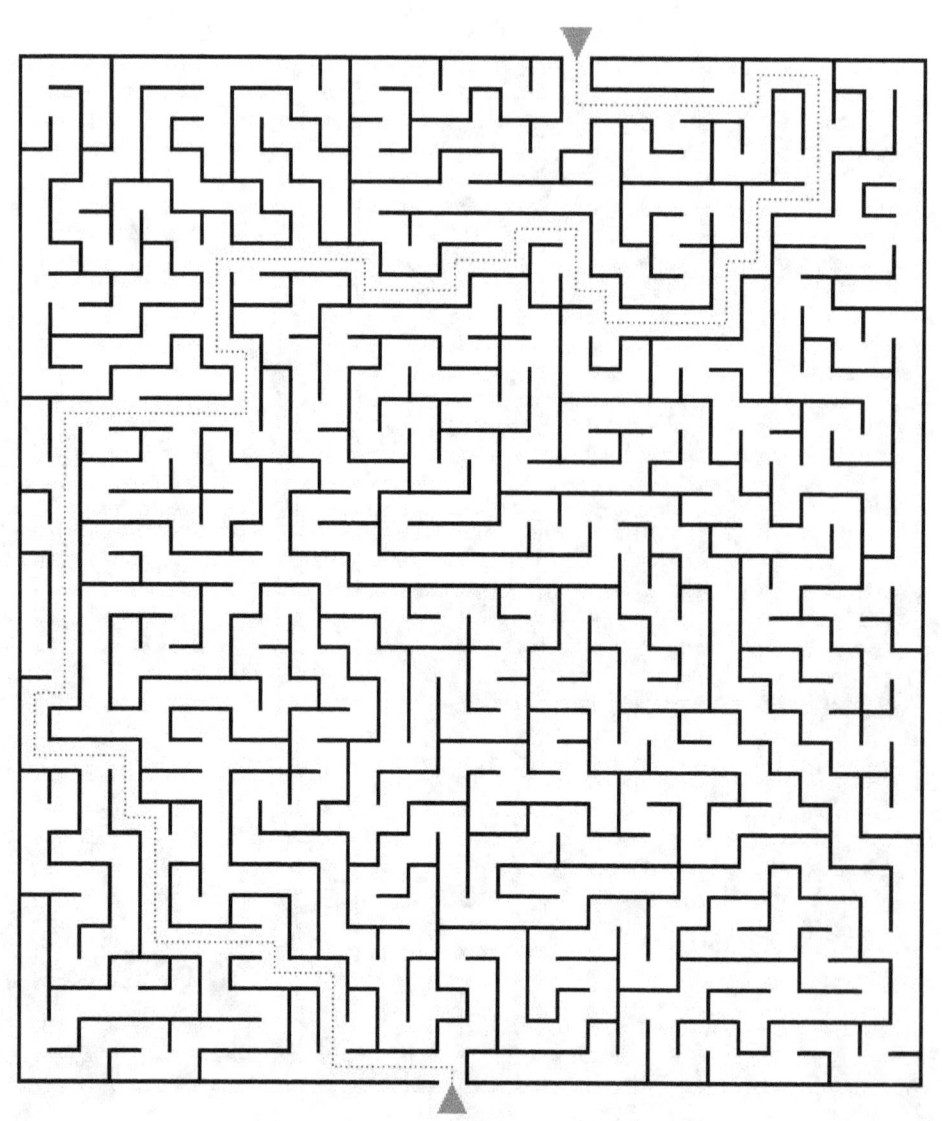